C000170474

LOVE, AIR

POEMS

LAWDENMARC DECAMORA

atmosphere press

For Ira, of course.

CONTENTS

Non-affiliation

I feel blessed for this trait I inherited from karmic fire.
I will reveal it when hollow-eyed manuscripts burn.

I get so lucky my drawer full of expired driver's licenses
survive another etui's unbridled conversation w/ ennui.

I feel strangeness crawl like time in the machinery of space
& I'm headed for nowhere where nothing gets to petition

a Mumbai paratha-case of the truth. Truth is: I'm afraid
of marriage. Feelings, for example, are like cities

pining for new souls in the streets. Feelings betray
for special reasons. One, for gravity to evaporate the other

graver thought. Second, paying attention to answerless
questions is what Jacques Derrida meant by forgiveness.

And like smoke, we slowly disappear being so unsubmissive.
Finally, space sounds like maze, a garden in my brain,

only if it were to chase Gitanjali dreams. No one can tell
you how to be lonely. When you write a poem at thirty-two,

you think you're in the middle of a war. Nobody's war
but voices you scatter around parking lots as I sit on

the peripheral grass watching the moment watch you.
And the center of it, yielding to the diameter of wishful

thinking, used to be your own patient wheeled out
for his afternoon sun. You cannot tell me how to be alone.

Nor can they brand a ceremony of signs & sleep
across my name. Truth is: I'm afraid of marriage.

Ten Forty

The typewriter is holy the poem is holy the voice is holy the hearers are holy the ecstasy is holy!

- Allen Ginsberg

It's time to unwrite the evening narrative
& the sad reality of the happy truth;
as the orange clock ticks
thinking of how life works
for you & me, the meaning
the paper embraces to erase with blank
formalities of forgetting, slowly
dips my little thoughts into footnotes
of ampersand sliding in and out
of the typewriter ribbon.

Maybe the hallelujah ting & ding
can explain why sound percolates
like a scherzo of human shadows
singing to the moonlight,
ribbon-smudging the distance
between Q & P, or marking linearity
(once reality's struck) with the black
nylon touch of Work, its singular
carbon-paper plan for the people.
Of course, that's nothing but *it*.

As memory hits the narrowed walls
of offices, remember the satisfaction
of punching keys, the joker
delight of your curiosity

that wants to grow like joker trees.

As you type up the words
for me, I don't marry the idea
of top-down aesthetic control,
the Rat-a-tat-a-tat-Pling!
of that percussive encounter
with Michel Foucault. But partly
I do recall Burroughs's *Naked Lunch*
on the other side of the page.

Under my fingertips, you know,
is a shore of syllables, the clickety-clack
of words hedged by tabs & margins,
turning language into geometric
auralities of remembering
& remembering.

Now that you're mine, Remington
Ten Forty, *rêvons de cieuxnéon
et de l'amour, l'amour, l'amour.*

Death Cab for CoViD-19

Ooga-booga, a cure-song for the majestueuse!
I went out for a walk to hear the virus,
spreading the anthemic royal sonic
sutra of *yada yada yada*; out there old
laughs at empty grocery shelves dwindle,
howling in pain. Mornings grew on flu
that flew across Grouplove Park, sans recovery.

Ooga-booga, madonna of the eternal quarantine,
don't sing for the eletro-magnetic subhuman abyss.
Not so fast that we may know the way out;
and find another cure for our existence.
Bats remain bats; they glide, eat and live.
Chantez pour l'amour et l'égalité...
Ringtone of our indiscriminate skin!

Call you DCFC or what? I held my hand up
for your return, for silence that has been
dowsing hospital beds, curfew-quick
hours fumigating the hurt of home,
And for the bouncy gigues crammed in this fix,
I held out my hand crying *Please, please.*

Ooga-booga, the scarred body chimed
without instance at six before nine;
I thought philistines were allergic
to darkened rooms with moisturizers,
as the rest of humanity saw social distancing
move against the tide of the tourists.

After a pleasant tea, life begins again.
You'll be happier than me. Virally concerned,
I freelance the whale of being OK,
and oh—the warm water kills me.

Funnylove

There is a kind of love called amnesia
which checks the insurance and doesn't
remember the migrations of birds,
which registers forgetting
like the brains of chimps
donated to science, which stores
forgiving and knows when to free
the flame from long-ago rooms.

This kind of love offers a truce
that will burst the bubble
as honest as it hurts hitting
the funny bone. But you deserve
peace in the east and west,
a Eucharist beyond the government's
calamity loans. You deserve it,
euphoria that glows only for you
every time sunshine goose-steps
across your bedroom floor.

And this kind of love can re-invent
you and me, like old devices
in the attic in this time of pandemic.
You know I adore the parts
of the house where closed doors
allow distancing. This is
when logic follows the law.

But I miss you and there's no more
logic to which I'm committed.
I'll just dig a tunnel from my window
to yours. This architecture of ours!

Lines depicting lovelight from your eyes

Last night I scribbled a note on the back of my hand.

It read like maps swiftly guiding the flash of chrome
& dark proofs to disengage from what's ancient there:
pain.

Pain—not to complicate it—what do I know about it?

I just know the bright air that hangs freely near
your newly cut hair, your point of view that sees
gravity
 at work.

I love the perspective you give to the flowers at dawn,
even the grammar that puts normal lives back

 in composition.

The lines drawn to my hand were tracks to all
but beautiful things inside you.

About you many good things come into relation,
I think of the constellation, vessels & viaducts,
the process like the lovelight your eyes emit,
true music
 invisible

 against the words.

Because this poem is about you. These lines shimmy
especially because they're in love

<div style="text-align:center">with you.</div>

Only do we speak of the night without reason

Tonight I talk to your image
as I talk to myself
surrounded by the little
particles of sadness,
stillness or constellation
I seek in your whispers,
the light my April senses
celebrate with the Folköl
and pale late verses.

Tonight I write your inner
iridescences, the green
shorelines radiating upon
your shoulders, touching
my speeches over seas
and oceans. Your mouth
against my ear, blood-coloured
satellite of time, oh this eternity
draped with our desires!

I speak to you tonight.
You speak to me tonight.
Poetry emerges from
the things we camouflage
under the Kortedala moon.
The best reason for fire:
passion. I speak this to reveal
myself to you
to reveal yourself to me.

New Year: Notes on Air

I feel terribly whole tonight; it must be
the nightrain, must be the proud
No Fireworks sign out on the street.
I feel terribly dangerous
like when I arm-wrestled the minutes
to tap out before 12 AM crept in.
I think I could smash bricks
w/ my bare hands, screw or shout
until the pyrophile agrees
to deconstruct the night
into constituents of steak & cheese.
But it's the New Year,
it's for me to remind you
you're a strong woman
& maps are makers of the endless
Derridean *khora* no one knows.
Only do we speak the language
of time & life in general,
facing & healing it
& as the old years burn away
moth wings marry the air, the free.

Far

Caught in a prism of light,

alone in the calibrations of colours,

I began to seek your future

in the reflective age of information

with sunlight. This or that, alone

on a stage of personal flower,

I was just so many different

engines of attention: a shy numinist,

a confessor, an unaccountable joker,

an innocent who can't have

any idea of what it's like

to be in love. An island of such

great complexity, my heart beamed

still through worlds, worlds.

And I began to think of you

—today, tonight

and for the rest of my life.

As a young Filipino horologist listening to Los Campesinos! in a small town in Wales

Happy Fiesta to my peripheral, sentimental and coastal Daydream-nasium

of a town! My memory of your image is once a happy town, a toponymy

of diasporic huts w/ Llanfairfechan across its name. Holy Horology!

A town full of fruited history, of saints & scouts, photography religion,

fiction & flood. Holy hippocampus flower it eschews *Miserabilia*!

A town left by bearded egos who come & go, & who continue to hide

human issues in prince automobiles. A town whose poor little hearts

have flown over tenement roofs & high above my *Avocado, Baby*.

Holy the discus throwers w/ clout goggles who'd want to canonize

Myron! A town forgotten by new souls who paraded their dreams

of bleak capitalism above the skies International. A town whose 21st

century local politics roars on the river, long romancing the neck

of dynasty. *Hello Sadness* – holy to your shiny entrails! A town whose

landscapes turn into etuis of foreign ornaments, of ethnicity glowing

w/ blood & ink & loafing. And I was just thinking, wishfully

thinking, what if Dylan Thomas & *Renato Dall'Ara* met in a pub

to predict a monster like the Coronavirus? You say it's a matter

of principle, I say it's the point of view of steam bakeries each open morning. Holy to *5 Flucloxacillin* entering the mouth! A town – my hell of a brain - well-conceived in theory, but doesn't exist in life.

Quarantine: A Song

Somehow the cure is kept

in the hips of the wind,

in the neck of the trees

in your village where

you waited for me

to declare, oh, my mouth's

a closed souvenir shop.

There was in my breathing

an image long quarantined,

a feeling squirming

through tiny cracks

and tight checkpoints.

A fresh start to trace

my path to your fever

dream's thousand tremolos.

I kept silent, my lips fuller

from your pain's sweet

medicine. They're wet

with what you've overcome.

And like sugar in the new

normal's breath, you gave

me morning, my dear,

as you gave abundance

to agriculture. Light

would embrace the shades

again. I thought I saw you

standing by the silver lake,

and then I thought

I found the cure.

Agnotology

If it were possible to arrest the sun,

I would be ignorance counting down

your nameless beasts,

 the swallowing yellow

of your hair,

 the slain light

in between trees and radio

static memory.

 I freeze.

I am no sunshine

that spreads more beams. I

am no other. I

 forget.

Untitled #1 (love is a Žižekian catastrophe)

There is a prism. A stillness

of the sky consuming the weight

of colors, of life's enough indulgences;

pockets full of kryptonite you

mesmerize with your flower of madness

kissing the mirrorless shadow

into a catastrophe, like when a lion

resides in the trees no deluge

is pronounced as biblical

as your hopes and fears. Love, you say,

is an achieved world order.

Perhaps you are missing the point:

you are a blizzard, a squall, a storm.

Torrents of everything that I love!

Untitled #2 (dialectical materialism, or this Night on two legs)

A flowing sand
and an invincible church
surround your patience, and deep
with its radiant *beyond*
—this Night, this blue country
on two legs, celebrates love
at the *edge* of the world.

Iralogy: A Study of Air

She doesn't really speak.

She sees the rainfall
so domestic as that sight
of home revivified on crayons.

My trusted typewriter
wants to celebrate her,
one Thursday night in June.

She drives past the flaming
fields when I can't figure
the nonchalance of smoke
as that of life's arithmetic.

She looks homeward
and sees no regrets
guised in purple clouds.

This carnival of hope
she's stabilized, memory
sitting still on Ottomans.

She's leading a simple life
outside of Miras
watching the world walk by
in its curious shoes.

I think what she does
each day is beautiful.

She's already in my heart
long before Bosphorus parted
the world's ancient fears.

David Lynch

In the singular eye of the evening sun,

there is a hole inside between something

and nothing. A light. A rush of wind

in the gathering gloom. Untitled

as the name of silence that coils

around your fingers. Quaint beauty

swimming beneath a matchless dream,

a flow of rhyme and riprap,

the same deep water as you.

Rabbits, rabbits, rabbits!

The Ampersand Night Parade

Night nude as art: this sight
studded w/ stars & winged
confessions is the best view
of the future, indulging us
to read into the footnotes
of monsoon in a magical way.

More positive signs than there are
in heaven, the night falls
on your hair like tiny secrets
sleeping soundly behind
the hedgerows. This night,
unperturbed by human problems,
goes deeper into the films
of David Lynch, that enough
quietude questing to reveal itself
industrial & Surrealist
in the unified field
of consciousness.

Night as a self-portrait
of silence: your sweet night
of many forms, I guess

is happier now than the music
the night sky borrowed
from chance, your life's
affirmation that is a mark
to be predetermined by
a parade of ampersands.

This night, this strange
feeling sinking in...
once we understand
no one understands at all!

In Kinsale, a howl is home *is* Irish

It's all right.
That open window to your precedents,
once it tumbles down
after shaking the earth's disease,
I'll parry for you
the brisk blow of emotions
in the lateness of the world.

I hurry home as though
you are there blinking with your fist.
The night sabotaged by your fears,
your fantasy castle
built upon my brain,
your kindness
the self-portrait of silk.

Even what was beyond

Kinsale was recast

in your dream's silhouette;

you gave the town

colourful wings winnowing

over hills and harbour,

its vibrant history a mouth

and a howl,

its ancient spirit your new mead

so you can float across

the tops of pubs contemplating

the signs of true love.

Forever thirty-three

Tomorrow you are possible
and I am very positive
that the universe took
its time on you,
crafted you first
in the order of taste,
a hard bright speck of unicité.

You prepare the art of life
like semi-autonomy
that takes the reins
in the kitchen,
learning still
to offer the world
at thirty-three.

The night, blue
and laundry-sweet,
opens itself and you enter
somehow wondering.
Everything waits for you.

Your day is coming...
I'm waiting for it...

Blow out the imaginary
candles of your imaginary
cake.

Think as if you're that
nine-year-old
sucking the nectar
out of each santan flower.

Sometimes you'll cut
the steak into strips
and make 'em look
like ribbons.

Think you're celestial
for a day without
the material, Japan
without a Tokyo.

Sometimes you don't give
a damn if B117 is the love child
of CoViD-19 and fascism.

You can dance in the kitchen
on a Sunday night,
singing like only
a lucky birthday girl can.

Your day will be brighter
as these lines humor
your heart.

At thirty-three, love
has come for you, breezing
an effect like the Fujiwhara.

Maligayang Kaarawan

Today there is joy in clean laundry.
All is submerged in water:
billiard balls, old paintings,
postcards and polaroids,
the Gramophone.

But the roto picture of your ego
in white shirtsleeves shows
something you'll never
forget: how you'll look
in twenty years,
how your passion
is interpreted in every line
and scar that's reflected
from memory.

On your day, I will celebrate
your eyes' uncalculated blink
as it might change
the season from tinder-parched
mornings to being fifty-six
and still writing you poems.

You know, I'd like to brush
your hair when things
go ugly, as when a tsunami
hits the seawall and there's
no one to fix your hair
out of fear.

Last thing, please let's do it
in church. It's not what
you think, no. I mean
let's do it, the laundry.

Oh the laundry and these
honest words? They're lovely
as saying *Maligayang Kaarawan*
or Happy Birthday
to you in advance.
Honest, lovely—these words
like a drop of blood
in your glass of milk.

the absence of birds

words are birds

words in transit

 space

be birds

 the shapes

 of permutations

congratulations!

from Manila Bay to our bones: we have no idea

 how beautiful that sky lantern

 is to six *acacias*

when it falls to the ground

when it swims in the chaos of colors

when we take out the words

when we see people manage their hours

between cityscapes & a birdless sky

 memory foams

 & you realize

temporal: i

I am amazed by your peace
and sleep and your breathing

squarely in the quiet air.

Being Air

Air as distance to your voice,

it speaks multitudes of words

that convey constancy.

Honest frequency of time

pliant as this cloud

of tomorrow, that there will be

another wave for us to channel

truth. What is as steadfast

as vapor is as porous as this

very moment. I like touching

your heart in the presence

of nimbus. It makes the air

swirl like a bodhisattva

seducing our mirrors

of reality. It makes the air

you breathe bounce off

the walls of my *dasein*.

It makes me breathe life

again. And for one more

neon of trust that streams

through, I will breathe

the spotless, forbearing you.

Beta / Meta
in response to South China Sea tensions

1.

Catch a glimpse of my moon-shaped heart / sire a vision / as you
 sail across my sea

of affection / Take a look at my three-bodied musica bolero /
 singeing (meta)phors /

grey skies over disputed waters & remedial Spanish / our Pacific
 mono no aware

w/ second-to-none maritime territorial integrity / What is it like
 living in

your afterglow / when sea & sky never touch each other / & the
 planet is forever

a mystery to explain / supercalifragilisticexpialidocious

2.

 When I kiss your chest in the morning / for good tidings I know
 it's a test / When I

see you shimmer in the gloaming / the simple things are the
 hardest

(I guess?) / Silhouette's a stitched woe / faith I reconcile w/
 lightspeed & lost

vermilion / like the throb of first love on spindrift spree / shaping
 my outlines

is a siren on a West Philippine Sea island / filling my eyes w/ the
 sound of sand

/ & an emotion you don't have a name for / Give me
 Hallelujahs! my dear / Bones

will sing as we ossify the present year after year

3.

My beta Man Booker understanding of nature spells out / a
 discourse

of amaryllis / or blooms divorcing the flight of birds of higher
 power / semi-

somnolent souls lured in by tramadol / Tell me how many
 squawking signs

can afford us a U2 concert in Manila / how many supertrees can
 protect human lives

from the world's nukes / how many moonbeams can deny the
 pulchritude

of exit marriage / of marginal rights & the nine-dash myth (or
 demarcation line) /

& how many stereographic indecisions are out there / how many
 seas /

how difficult & free

Dear Synaesthesia,

I heard you looking...

I smelled you touching...

I felt you knowing...

I dreamt you tasting...

These were the odd

conditions when you're

totally smitten

by a venomous aura

of human emotion.

They're like the teeth

of flowers ready to feast

on the rainbow's flesh,

clandestine Cartesians

to disembowel the lighthouse

of our body's atmosphere,

tall, principled, composite.

You are, however, a creature

yet to be named. Angel of dust,

your vision simple as a ring!

I held your incandescent

soul up toward

the immaculate sun.

It has purity about

to spread her free wings

so wide no muck can ever

blacken, nor can a Greek

thinker or a Spartan soldier

overcome with triumph.

I never knew dancing...

I was a terrible writer...

I didn't know Braille would

translate for me my stupid

thoughts about death...

love, in Rococo style.

These now are the sane

inhibitions when you fold

grace into a mute hug,

butterflies and some trees.

Learning kindness from New Order's *Temptation*

A heaven, a gateway, your magnetic kindness in polycarbonate

quantum word expression. Romantic as golden blue, you make me

take the holy chance, this moment with you lights up my mind,

explains a phenomenon only you can decode by ice star and thistle rose.

A barometer, a wise shadow fading into you after me, this knowing

gaze of fate channels a probe into every chapter of your good heart.

Speculative as your bright-eyed future, you reconnoiter the frozen

references to my silence; how the people constantly miss

the kindness other people enveloped in the east and the west.

As to why a leaf falls from the sky, I never ask why. I never ask

why kindness binds and frees, why it can be, like temptation,

swirling

 with the seasons.

Before Sunset

I was walking, contemplative
as this new life that had sprung
from the corners of my eyes.
I was wandering here and there,
fresh feeling commencing in me,
and you know those old houses
raised on stilts over the surface
of history, they belonged
to your state of charm swaying
between the aromas of the Khmer
sun and the gaiety of gerberas.
It was before sunset, and I was
wasting in the sultriness
together with the cicadas,
and as a boat in a daze
I was almost traversing darkness
in the middle of nowhere.
The air was penetrating me
and having me, like your solemn
touch of the rest of love.
I was a kite awash in your zephyr.

Vespers of quite Hesperian blues

1.

When all of the time I thought I was sad, I counted the stars on the ceiling to remember how we've met before. It's recalling the beauty of God's sent postcards with no name written except yours. Your handwritten name introduced me to the ancient truths of humanity, your world entering the cells of my sleep; and lovely as this room of mine, your laughter forever ago became a silhouette beyond the absorbing walls, unlocking its strong perfume of fears despite the rain outside.

2.

In an instant I witnessed the waltz of a taxi like a gray smoke above the lane. I told the driver to listen to the sound of the pouring rain. But it sounded as if a private life seemed unachievable to him. It's not about shuffling around for a random route. He then gassed up, all glued on the road, self husked by the evening light.

3.

I could only flash the broad simplicity of walking, how in my dream threaded with vespers—you took me to where you played

when you were young. And there, without a word, you opened my veins and poured into them the clear current of your soul.

Northerly

In life, we are playing with dangerous games: you, the witness
of the visiting vatnajökull now blushing pink in the atom sky
with the bright comedy of Borealis fooling the ashes of the colour,
and I, making a cryogenic favour to the moonless nights,
to the mountain echoes teasing tourists about salmon sparks
caught in the arctic splash of water balloons and whispering
endless cold, happen to see the world in your eyes—spinning
with the silence of earth. My eyes flower, semen of a star.

Longing, with the logic of turquoise

Longing is taxidermy—
and I long to study
how I can propagate
memory from fire to fire
until it wears without
knowing that you live
in my heart for the moment,
a sudden magic without organs,
breath without salt
your skin remembers
with the logic of turquoise.

I want to wear your smile
on my sleeve, crystallize
your thoughts, secretly,
as when a taxidermist
preserves a creature
for immortal longing,
desiring, the ornamental
shaping of feeling
between the shadow
and the soul.

Oh I long for your body
to substitute the signs,
moving with care
and obscure pride,
so close that it enters
our world, so close
that your eyes close
with my dreams.

A hard rain caught between the plain eyes of the season

It came like a splash, an unfamiliar note that dropped bombs and bombs and bombs of fateful narratives that brought us together. I don't know what year you first sang the blues and made the breeze so easy to convert facts into wild horses of strange attraction. It was simple arithmetic of sort. It was predicting today's weather report. But you showed me how rain was to be construed with mystery, read as if it has no bouquet of words, no garden of solace, no meaning after all. Only rain caught between the plain eyes of the season.

Remember how you bicycled ideas off to remain in light. Remember how simple things in life can be like the tired feet of dusk kissing the skin of water. Remember how beautiful it is to be free, to love raindrops and verses mornings after sweet mornings. You know too how lucky I am to write these words amid the storm. A mottled bird cooing in and out of time. Your bright chandeliered sky over my poor soul: a beginning of something wonderful. Rain as curtains of the earth's wishes brought me to you. There was music: and there were commuters and moving cars and every day you and me.

Nightbirds

They call themselves June and May.

They wait miraculously for two hearts to say.

They sing together seeing the old moon

wound its ego gay.

I believe in the marriage of night and day

as I let the hours pass thinking of you.

There's a quick message

my mind transmits to the tree-limbs at night.

I tremble because I care for you.

I tremble like the words

tremble inside a jar.

And I look into your eyes—

vacant, static—I see myself

staring back waiting for your acceptance

veiled in hymns; something the nightbirds

ought to confess. My time-feathered will,

you know, is long and patient.

Goodnight

Say it for I will not sleep.

Say it for you will find comfort.

Say it though it may already

be the 55th time.

Say it when there's no other

word to soap the hurt

of yesteryear.

Say it when you can exchange

foie gras for a can

of the impossible dream.

Say it as hours evolve into flowers.

Say it on a moonbeam bus

cooling the air.

Say it with champagne

and champignons.

Say it deep in the hypoderm.

Say it with extra vim.

Say it over the rooftops

of the world. Say Goodnight.

Say it now. Say Yes!

At Patcharawan's

There are no easy pathways for two people trapped in the Corona-verse looking for an endless story with splendid evenings. In peacetime you can find hope served on a platter by means of armistice, the city square between us blankets both time and lies in favor of the size of our fantasy. Opaque as the dreaded life of this plankton fear on earth, I remember everything about the bridge that guided our dusty feet to the place where the conflicting east and west of history fold up to the frozen reference of our starved feelings: at Patcharawan's.

Behind us are the savory spirits wrestling with the tar-smoke of the past, the noodle in the kitchen sways like the bridge above a great shattering. I love the moon's tender reflex of its tomorrows, or the afternoon in our hands against the wheels in heave and salt. 4:27 in Thai broth moves with the wind past the intimate sunset. The bridge in your mind: this life is not the same as your other life. We have only to keep walking for the bridge to build and bind our future.

One Sunday night at Subway

Saccharine, tender, fresh...
these are the words that clung
to my spine when we tabled
over at Subway one instant Sunday
night that sat upon the imaginary
blooms. It was like a night with
a membrane and a microphone:
that sweet chatter spoiling the hours.

7 o'clock, no it's only time
it's only the beginning
of your homespun tales you told me
about philosophy, retail marketing,
finding directions, about life
in general. Your silent face sang
to my affection in secret. That moment
I wanted the world to stop.

Finally at 8 o'clock I couldn't
remember the way out of the mall.
It was like learning a new language
or solving the Rubik's. It was
like your charm, I got lost
in its mysterious translation,

too clever for me to mull over
and say, I'm home.

Talking about home?
I was hoping Subway wouldn't
dim its lights as the night
before us continued to shine.
With those unsure brief moments
With you, I thought I was home.
Your words flavoured my eyes
with hope, and oh how could I
forget—they too served a binary
recipe to true love: Steak & cheese,
steak & Cheese, Steak & Cheese.

Eventide

Here we are at last, alone

picking up pieces of pure bark,

without loneliness, far from

the consumption of luxury

and cement from corporate

deliria. I open my eyes

with a sight as clear

as this reality pounding

my heart like crazy—

that's you, my dearest.

Oh I cannot lie it's you

and your luminous mind

that fill the world with mynas.

There are naked lights swirling

in peach and tropicalia,

subterranean nights too

are in bloom for faded

melodies to flower right

in your silent face. I got lost

in the night for so long,

without a heavenly outcome

like the scent of your eyelids,

but when the night surrounded

me I was born again. I can

now recognize your rays

of rays, because you are

to embrace your life anew.

Hyperballad: Notes on Air

Since I met you
this small place in the dark
finally a got a room
for my big feelings.

Since I met you
mid of December
I nicked a parachute
to sneak off to an island
where you are there.

Since I met you
after you fought a war
I never asked how
you've won it
but jumped between
the boats to see
your sun come up.

Since I met you
I began to adore the nights
and the way you rattled
the charm of the word
'soon' as though you've
seen katmon leaves
dance in the breeze,

the future consumed
me with its fire
its art of collision—
how beautifully

you've seen it all.

Since I met you
there's more to life
than old joys in a ball
of yarn. Ever since
I came to you I adored
the motions of the clouds,
the pulse of late summer,

surreal flight of things
I thought had existed only
in Michel Gondry films.

Ever since I met you
birds did collect before me
as the things you do
each day astound you.

Because you knew
I could send the words
across the world
to follow your heart.

Waiting for 9:41

As your busy hands flew against the radiant rocks of the day, full of touch without repose, I felt the conjoined circles of bliss and seaweed, that by your side the waves suddenly rose, everything glistened as one and one touched syllables: the foam of your sweet success. And then your hands fluttered out of sight, out of touch, out into the blank empires toward the deserted cities, cryptic castles, sad tunnels or into those pale walls of a closed chamber. Where have they gone, my dear? Those seraphim of the faithful and onion flower buds. Those hands, yes those hands of love and labour. Where were they? My search pregnant with hope, oh there's no siren or demiurge that could put it to waste! For my hands have long searched for your hands resting in the ravines of our secret earth...

Plainsong

The first day was Monday.

It was called yesterday.

Second day's Tuesday.

It is but giving birth

to the plural stars.

But this day's caught

by a multitude of tonight's

charm. It is full of light

and art and gravity.

I was drawn to it

because it has your smile.

Maps & Minuets

With maps I begin to chase
the far east of your breath
with my words upon many
a triadic encounters and silences
I could only surpass when you're awake,
then sleeping in, a reflector
of hope from such great heights of rest,
that would scale down in corresponding
shapes, colors and sound
and would still be around
the morning after.

With the news of the day,
as when a typhoon is staging
a minuet, I realize how your little steps
thresh to minty blue
to make the sky fall forever,
how slow for seaquakes and heartbreaks
to scream your effects on me,
but out our windowless world
you are the heaven's order,
and with strange powers
you give the seasons
a thousand reasons
why immaterially I still
would want to exist.

The Science of Spiral *Alaala*

Neither have I books nor time
to spare; there is only the tide
that turns for you, that lifts
my chances of celebrating you
as we ride on a tiny paper
boat sailing in dreams. No wonder
I remember a summer's day
of walking up to you. My face
turned red. I remember staring
at my feet. I could have said
the words in 2005. Now I'm a dancing
June bug, look! It's cool that I
remember what I can't explain.

I remember your laugh and gravity
and serendipity. I remember *now*.

sometimes

new life (when you notice
les couleurs) like rain
in the arms of the night
sweet & light tonight
capitalism in sight
sometimes
i question things
no not to please
the wind in your hair
the cars splitting
reality here & there
i just want irony
to swim in the skin
of human existence
& i'm the first to admit
i believe in people like you
believing in people like me
so ecstatic as gold
in the June air of two
shiny eyes gyrating w/
things though it's only
goodnight it means something
a question of time
(perhaps)

a question of pride
(maybe)
i just want to see you
(imagination)
cellophane bees meander
through fields of lollipops
as tall grass as power
but in this show
of remote concerns
i'm not complaining
your pleasure's
my sugar boat
& my dwelling
only sometimes
reminds me
of begonia skies
of one times two
the dirt in your son's fries
caring is true...

though it's only goodnight
it means something

The Universe

after Sengai Gibon's *Circle, Triangle, Square*

[Square]

You have an affair
You risk telling a story about a bruise
You have two swords (each victory a solstice)
one leads me upon the feet crashing into home—
the east and the west hands are two divorced yams
sighted by a giant one-eyed history
thinking fondly of fire eating fire—
while the other points toward the direction
exactly where the axis is sabotaged
Cornered by the elemental shapes of three
—*Circle, Triangle, Square*—
these capital interstices of spectral marginalia
you turn up to the fact
the world is a nipple that feels compensated
on the vague hands of water
Ah water—yes!
What about the ears that suck the wind
Well it's a matter of feeling
Remember what your heart is for

Katsu! Katsu! Katsu!
Let's okay the kites anew

[Circle]

Under the saccharine formation of return
you birth from the bladder briefly bled
sleeping off the altercation of pagodas
in the mind of every artist baptized from within
admiring the city of ink where you hibernate

To the sacral temptation of *satori*
I believe you carry enlightenment at your behest
A form of teaching that life can detonate
into a pure spirit bomb of meditation

Silence you mean revolution
Planet I say temple
Here in the bamboo garden the raccoon
spins a cycle that never ends
No it never ends, 決して—
only gallicizes the accent of exhaust pipes

Under the circular masturbation of dawn

I remain angular at all points of leaves

for you will die and live and die, breathe again

And what comes after is the crowning of the shrikes

in the throat of the afternoon as your fingers

waltz with Surrealism, tomorrow's *bokuseki*

You will

 awaken

 the cup

Helpless wind doesn't know where to go

Helpless hair devours the avoided world

Helpless mirror reflects Zen like:

Katsu! Katsu! Katsu!

Let's okay the kites anew

[Triangle]

What seraph of time will you enter the cave

What flock of luck will you meet the Great

The walls you struggle to destroy

 Invisible moles of water

You drink and think

 yielding you a fiasco

What is colouring the grass
does not lionize the muscle of it all
You need to clear your head
the tattered ego said
Katsu! Katsu! what Mahāśvara advised
the dragons flitting from zenith to zenith
the golden cherries flooding their faux scales
with a tumult of sushi with eyes

O how you carry your weight
O how you translate *mono no aware*
O how you duel against the axis

You will never come down once you shin up
You will never will

The shogunate rule levitates the blossoms
offers up a slice of the red samurai sun
Dedicate your postcard-pinned ego
to the fruit of high power
taking refuge in your scapula
Make a vow that can be eaten by scrolls

O frogs shimmering their ashen parts
O dear life to feast upon the *inka*
Hope is squeezed from a masticated finish

You will graduate as soon as *Katsu!*

O the discipleship hires a master
a master of the teetotaling tropes
a master mindful of the seasons
And many years of speaking
in hushed tones you say *Katsu!* to all a few
and *Katsu!* to all of me
and *Katsu!* to the leaders of mountains
Katsu! to the Noh masses
Katsu! to the sleepers' pointed snore
Katsu! to the panda gnashing the heat's nails
Katsu! to the moon's harvest
Katsu! to the pond's music of memory
Katsu! to the system the city endorses
Now let me announce paradise:

Katsu! Katsu! Katsu!
Let's okay the kites anew

Thank You

On a thousand roofs under skies of ruby, I see a thousand leaves just like me, folding up, falling in a row. Upon a haunted street they tread, discrete like my heart you seem to fill with fragrance. From my head to my toes, from the words in a book, I start to watch the pigeons that do not look. And for these past few days I almost had lived underground.

From my knees to my nose, from the sighs of a song, I hear a silence that knows of a dream that can't be sold, and that for me you live in the real world. But for these past few days it leaves me alone. It sleeps off fiction and leaves me alone. Among the broadswords of your iron and lyre, your songbirds and their flesh of words, you may have read the signs wrong as I watch the sky. You may have sung the wind's blues so wild every time, and I just smile.

Acknowledgments

The author gratefully acknowledges the following literary magazines, anthologies and academic journals in which the poems in this collection initially appeared:

Sábanas Bilingual Literary Magazine ("New Year" forthcoming in vol. 8), University of Puerto Rico at Manguez

Meridian: The APWT Drunken Boat Anthology of New Writing ("Death Cab for CoViD-19" published in December 2020), Asia Pacific Writers & Translators (APWT)

Asian Studies: Journal of Critical Perspectives on Asia ("Beta / Meta" forthcoming in vol. 56, no. 2), University of the Philippines - Diliman

OF ZOOS ("Far" published in issue 9.1), Singapore

North Dakota Quarterly ("Ten Forty" appeared in issue 87 ¾), University of North Dakota, USA

Poetry on the Move 2020 ("Funnylove" appeared in Well-Known Corners), an online poetry magazine and festival of the University of Canberra, Australia

Quarterly Literary Review Singapore ("Non-affiliation" appeared in vol. 18, no. 4)

PAPERCUTS Magazine ("Agnotology" appeared in vol. 19), Desi Writers' Lounge, Pakistan

About Atmosphere Press

Atmosphere Press is an independent, full-service publisher for excellent books in all genres and for all audiences. Learn more about what we do at atmospherepress.com.

We encourage you to check out some of Atmosphere's latest releases, which are available at Amazon.com and via order from your local bookstore:

Grafting, poetry by Amy Lundquist

How to Hypnotize a Lobster, poetry by Kristin Rose Jutras

Love is Blood, Love is Fabric, poetry by Mary De La Fuente

The Mercer Stands Burning, poetry by John Pietaro

Lovely Dregs, poetry by Richard Sipe

Meraki, poetry by Tobi-Hope Jieun Park

Calls for Help, by Greg T. Miraglia

Out of the Dark, poetry by William Guest

Lost in the Greenwood, poetry by Ellen Roberts Young

Blessed Arrangement, poetry by Larry Levy

Shadow Truths, poetry by V. Rendina

A Synonym for Home, poetry by Kimberly Jarchow

Big Man Small Europe, poetry by Tristan Niskanen

The Cry of Being Born, poetry by Carol Mariano

Lucid_Malware.zip, poetry by Dylan Sonderman

In the Cloakroom of Proper Musings, by Kristin Moriconi

It's Not About You, poetry by Daniel Casey

The Unordering of Days, poetry by Jessica Palmer

Radical Dances of the Ferocious Kind, poetry by Tina Tru

The Woods Hold Us, poetry by Makani Speier-Brito

About The Author

Lawdenmarc Decamora is a faculty researcher at the Royal and Pontifical University of Santo Tomas. He earned his MFA in Creative Writing from De La Salle University-Manila and is now a candidate for his MA in Literary and Cultural Studies at Ateneo de Manila University. With work published in 21 countries around the world, Lawdenmarc was nominated for the Pushcart Prize and Best of the Net, as well as earning an honorable mention in the special 2018 Love issue of *Columbia Journal*. He is the author of the debut full-length poetry collection, *TUNNELS* (Ukiyoto Publishing). He divides his time between Pampanga and Manila in the Philippines.